ANNE GEDDES ™

ISBN 0-7683-2026-7

© Anne Geddes 1997

Published in 1998 by Photogenique Publishers (a division of Hodder Moa Beckett)
Studio 3.16, Axis Building, 1 Cleveland Road, Parnell
Auckland, New Zealand

USA edition published in 1998 by Cedco Publishing Company,
100 Pelican Way, San Rafael, CA 94901

Designed by Frances Young
Produced by Kel Geddes
Color separations by Image Centre

Printed through Midas Printing Limited, Hong Kong

Please write to us for a FREE FULL COLOR catalog of our fine Anne Geddes
calendars and books, Cedco Publishing Company, 100 Pelican Way,
San Rafael, CA 94901.
Or, visit our website : www.cedco.com

10 9 8 7 6 5 4 3

# Monday's Child

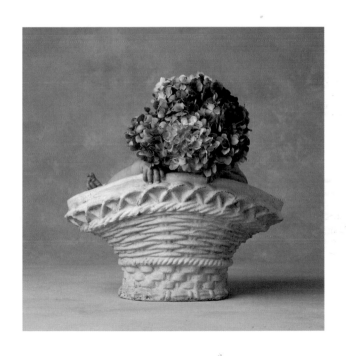

# Monday's
child is
fair of face

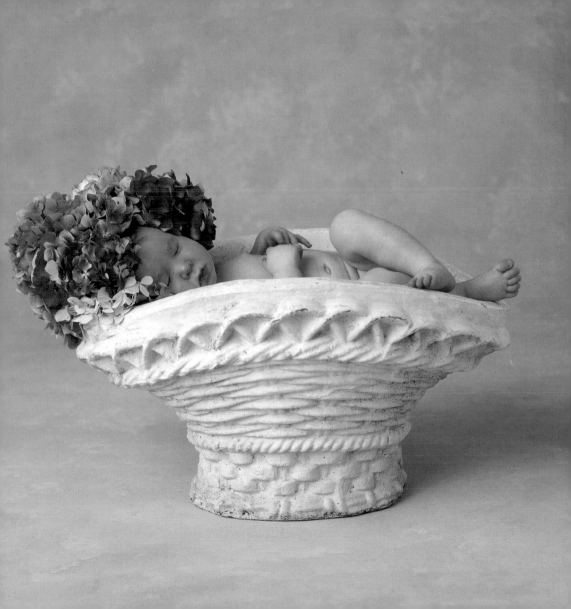

# Tuesday's
## child is
## full of grace

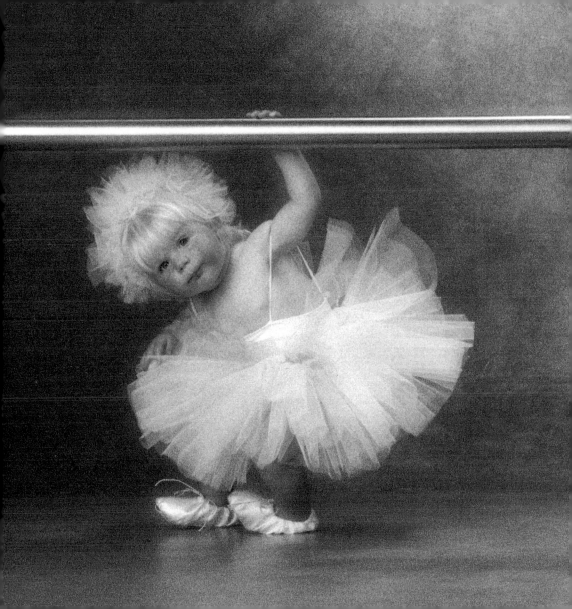

# Wednesday's
*child is nice
to know*

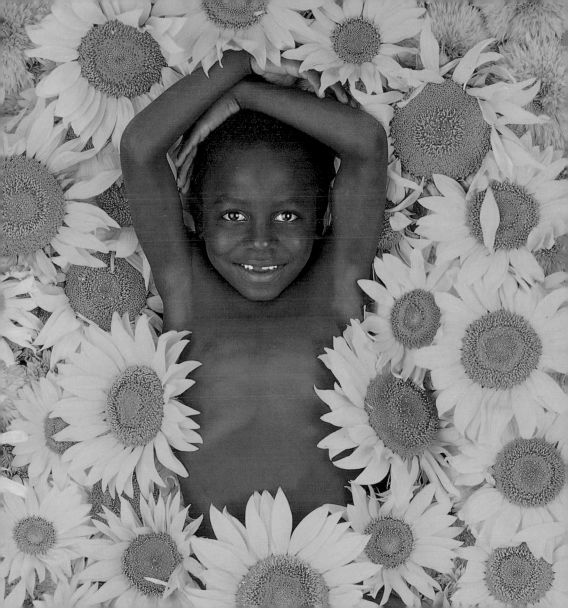

# Thursday's
*child has
far to go*

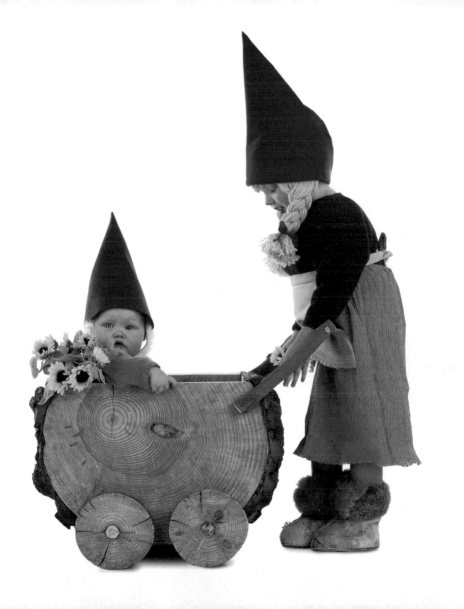

# Friday's
## *child is loving and giving*

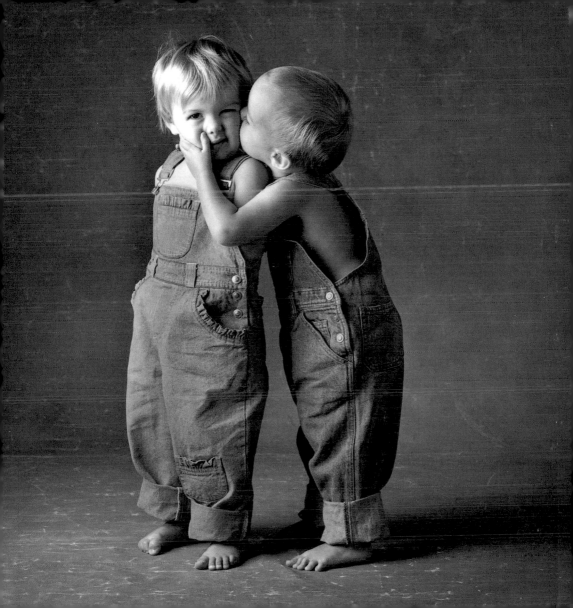

*Saturday's child works hard for its living*

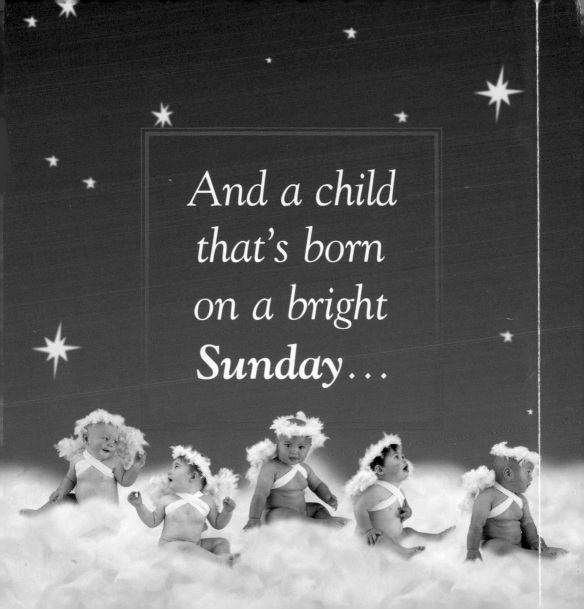

And a child
that's born
on a bright
*Sunday*…

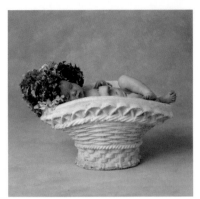

*Monday's child is fair of face*............

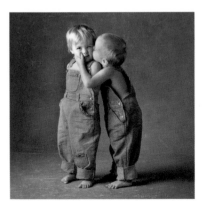

*Friday's child is loving and giving*............

*Tuesday's child is full of grace...*

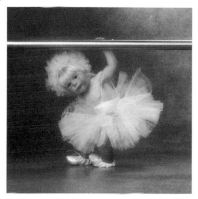

*Saturday's child works hard for its living*

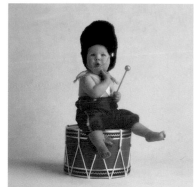

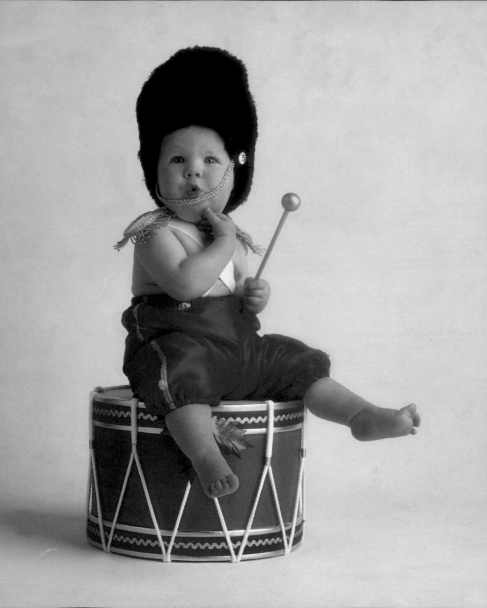

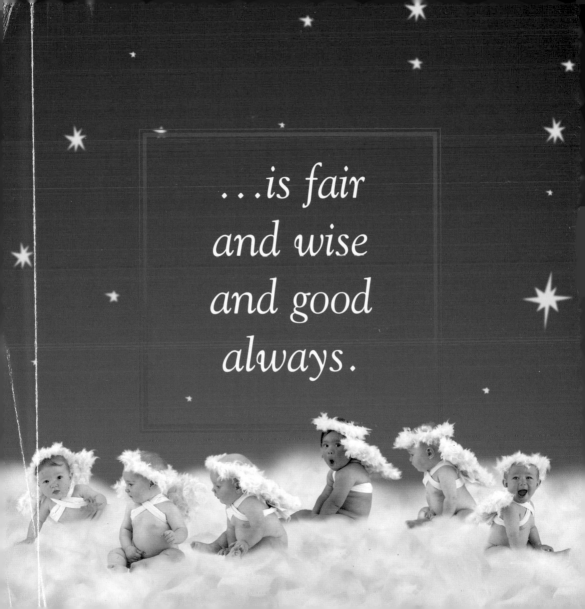

...is fair
and wise
and good
always.

...Thursday's child has far to go........

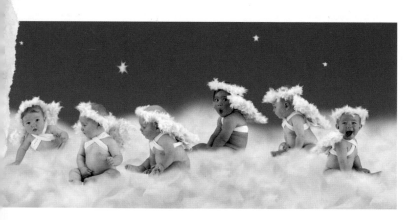

**Sunday** is fair and wise and good always.

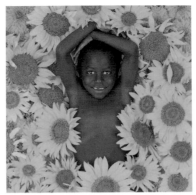

*Wednesday's* child is nice to know...

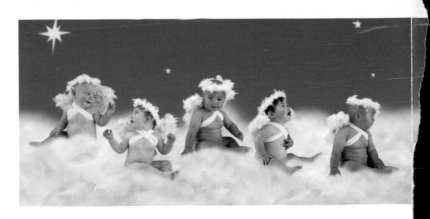

...*And a child that's born on a bright*

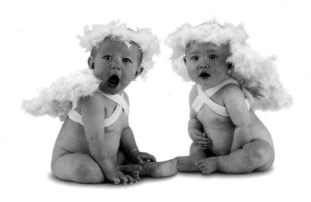